ROMNEY

1734 – 1802

BY C. LEWIS HIND

PLATE I.—THE HORSLEY CHILDREN

(From the picture in the possession of Messrs. Thos. Agnew & Sons.)

Few painters have rivalled Romney in expressing the simplicity and naïveté of children. These portraits of Master George and Miss Charlotte Horsley are excellent examples of his mastery of an artless pose, and of the reticence of his colour. How delightfully the flowers tell against the white dresses.

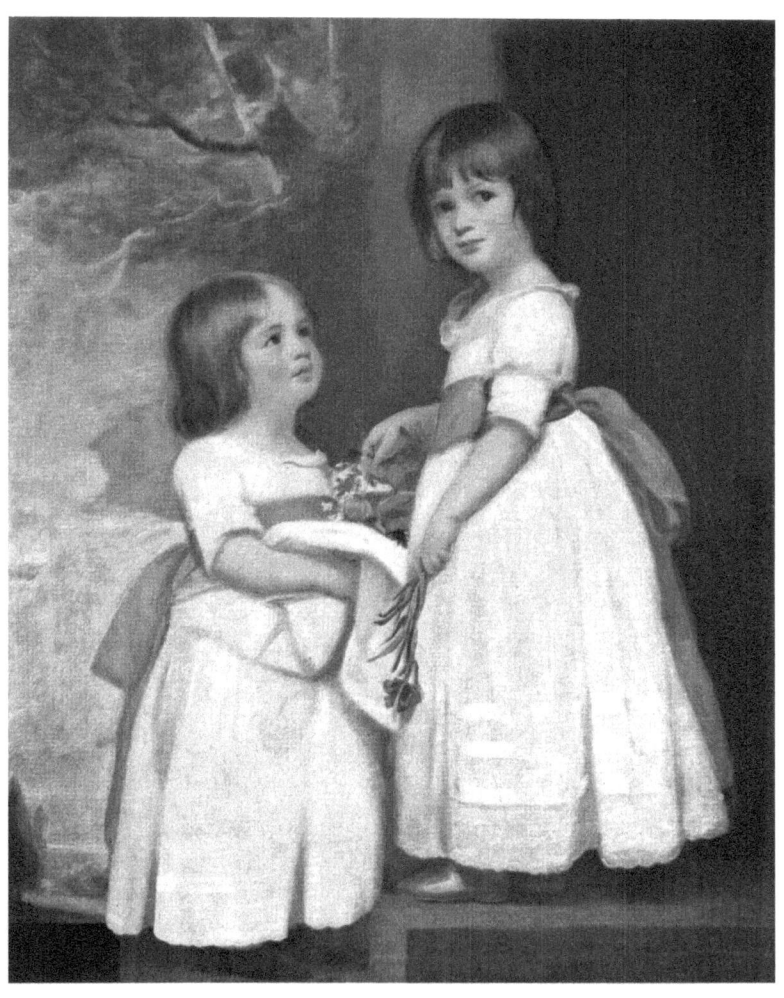

This book is an unabridged reprint of the first edition published by T. C. & E. C. Jack, London, and Frederick A. Stokes Co., New York, in 1907. Page numbers differ from the first edition.

Typeset and republished by Michael W. Gioffredi. Copyright 2019. MichaelGioffredi.com/b7hy

 ISBN-13: 978-1-0776-4869-2
 ISBN-10: 1-0776-4869-3

2 4 6 8 10 9 7 5 3 1

CONTENTS

Chap. Page

 I. Three Periods of Romney's Life . . . 7

 II. Romney, Reynolds, and Others . . . 18

 III. His Vicissitudes of Fame 27

 IV. His Portraits in Public Galleries . . . 33

 V. His Portraits in Private Collections . . 41

 VI. Emma, and The End 53

LIST OF ILLUSTRATIONS

Plate		Page
I.	The Horsley Children	iii
II.	Sketch Portrait of Lady Hamilton . .	11
III.	Mrs. Mark Currie	17
IV.	The Parson's Daughter: a Portrait . .	25
V.	Lady with a Child	29
VI.	Mrs. Robinson—"Perdita"	37

I
Three Periods of Romney's Life

HIGH over the western boundary of Cavendish Square rose a tripod wooden scaffolding, supporting a gigantic crane cutting the arch of the sky; on windy days the smoke from the engine was blown upwards into space. Below, twentieth-century mansions were growing on the site of old Harcourt House, for Cavendish Square, like the rest of London, was suffering an architectural change into something strange and new.

Some of the eighteenth-century houses remain, and as I sought No. 32, in the early summer of 1907, I wondered if this dwelling of memories had escaped the builder. Abundant memories! Into that house, through the later years of the eighteenth century, passed the flower of English loveliness, breeding, valour, brains, wit and frailty. For this was Romney's house, with the large painting-room at the back, which he, greatly daring, rented in 1775, to the satisfaction of the landlord, whose property had been untenanted since the death of Francis Cotes, R.A., five years before. Soon the great Sir Joshua showed signs of Olympian jealousy at the success of

the raw man from the North, reserved, silent, moody, whose acquaintance with the *beau monde* did not go beyond his studio door; who worked by night on designs for "great or heroic art," and who had a genius for fixing the fleeting loveliness of a woman's face so simply and fragrantly that we liken a fine Romney to a rosebud arranged in a pattern of artless leaves.

Sir Joshua, at work in Leicester Square, realised that the stream of fashion flowing to his studio had been diverted. He did not refer to Romney by name! He merely called him "the man in Cavendish Square," and be sure that some candid friend repeated to him Thurlow's public declaration: "The town is divided between Reynolds and Romney; I belong to the Romney faction."

If you think that plain-speech Thurlow exaggerated, glance at the verbatim transcript of Romney's Diaries, giving the names and appointments of his sitters, printed in the monumental work by Mr. Humphry Ward and Mr. W. Roberts. In less than twenty years over nine thousand sittings in the house in Cavendish Square are recorded.

If the stones of Cavendish Square had language! To No. 32 came Warren Hastings, Burke, Thurlow, Garrick, John Wesley, lords and ladies innumerable, the two lovely Ramus girls, the beautiful Mrs. Lee Acton, Mrs. Mark Currie, Mrs. "Perdita" Robinson, and the adorable Miss Vernon. Other men seek elation in wine, or spring, in Mozart or Grieg; Romney found it in the flash of a new face, "lit with the shock of eager eyes." Thither came the pretty Gower, Clavering, Warwick, and Horsley children, and one day in 1782 that "divine lady" Emma, when Romney was forty-eight. In she floated, laughter in her eyes, joy on her lips, sunshine in her presence—shadowed by her cavalier, Charles Greville, whose emotions were as pre-

cisely under control as running motor to a chauffeur. Thus joy entered into his life, and joy left him, when, nine years later, he painted Emma for the last time after her marriage to Sir William Hamilton. The syren having departed he was soon to be on his way—a broken man, still ambitious but ineffectual—to the arms of deserted Griselda, patiently awaiting her faithless husband in Kendal.

Having reached this point in my meditations, I came abreast of No. 32, and found a brand-new, pleasing house, without tablet or bust. Sir Joshua marched conquering to the goal: Romney fell before the last lap. I paced the square and thought of his life that has given immortality to so many. The eighteenth century is vocal on the canvases of her great painters. The other day I saw the two Ramus girls smiling from a wall in a house by Henley-on-Thames, and they seemed more alive than the goggled, huddled women that had just flashed along the highroad in a motor car. And as I mused by the trees in Cavendish Square, dominated by that vast crane—the signmark of new London—cutting the sky, I saw clearly the three periods of Romney's life symbolised by a *Horse*, a *House*, and the words *Home Again*.

THE HORSE

It is March 14, 1762. George Romney, aged twenty-eight, mounts his nag at Kendal and rides forth, with fifty pounds in his saddle-bags, to seek fame and fortune as a painter in London. Nothing matters but his career. Doubtless he is sure—or as sure as an emotional, impressionable man, taking his colour from his surroundings, but conscious of great powers, can be— that when his pockets are full of guineas, he will send for Mary

PLATE II.—SKETCH PORTRAIT OF LADY HAMILTON

(From the picture in the National Gallery)

Her rich brown hair falls in tempestuous disorder over a pillow; the mouth is open; the eyes are as near to tragedy as the volatile Emma could go. This sketch (circular, 1 ft. 6 in.) was presented to the National Gallery in 1898.

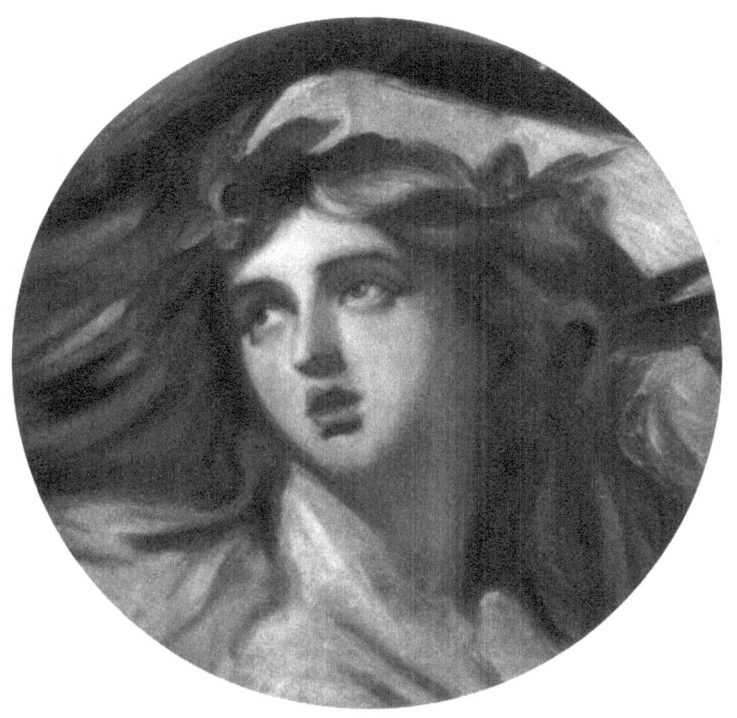

and the children; but that is all vague. He knows, if he does not confess it to himself, that he has outgrown the pretty, patient creature he married seven years before, after she had nursed him through fever in his Kendal lodgings. As he rides he recalls his early days in the farmhouse at Beckside: his versatile father—farmer, cabinet-maker, draughtsman, and a dozen other things; his affection for Williamson, watchmaker and musician; the influence of Christopher Steele—"itinerant dauber"; his stay in York, where he saw Sterne; the first picture he painted—a hand holding a letter for the post-office at Kendal; the portraits he produced at two guineas for a head and six guineas for a whole length; then more success, and finally that lottery of his unsold works at the Kendal Town Hall, eighty-two tickets at half-a-guinea each. The proceeds, added to his savings, made him master of a hundred guineas. Half went to Mary; and here he is, with the other fifty in his saddle-bags, a free man, jogging towards London. Somehow he will find the intricate key to fame. But first he must seek a lodging. He scans bewildering London, puts up at the Castle Inn, and a fortnight later moves to Dove Court, near the Poultry end of Cheapside.

THE HOUSE

It is March 27, 1776—fourteen years have passed. Romney is in his Cavendish Square house waiting for the first sitter recorded in his Diaries—"Lord Parker at 9 o'clock." Two more are to follow that day, "Miss Vernon at half-past 10," and "Lady Betty Compton at 1/4 to 2." Seven more are booked for the three following days, and on Sunday he expects "At two a lady." He is well pleased. Fame is at his elbow. Fourteen

busy years have glided by since his nag first clattered on the Cheapside cobbles. He has painted many pictures, always believing that "heroic art" is his forte, and portraits merely a means of living, and he has refused to exhibit at the Royal Academy, holding that public competition is bad for a man with "aspen nerves, shy, private, studious, and contemplative." In those fourteen years the *gauche* north countryman has seen something of the world. He has visited Paris, and he has made a tour lasting two years and three months through Italy, without which the education of an eighteenth-century painter was considered incomplete. Troubles he has had, of course. There was that cruel affair of the Society of Arts' competition, in which his picture of "The Death of Wolfe" won the prize; but the award of fifty guineas was, for some mysterious reason, withdrawn, and he had to be content with a consolation gift. Romney believes that Reynolds had a hand in it; but that is hard to credit. Italy and success and the Cavendish Square venture have blotted out that early disappointment. Taking Francis Cotes' large house was a bold step, and it had been complicated, at the critical moment, by an offer from Lord Warwick to visit Warwick Castle and paint a companion to the "very respectable portraits, chiefly by Vandyke, collected by the Earl." Romney refused that tempting offer (he painted the family group later), determined to let nothing delay the Cavendish Square plunge. How well it has turned out! Like Sir Joshua he has begun a Diary of his sitters. The hands of the clock point to nine. It is time Lord Parker arrived. And at half-past ten, joy! he will be shyly welcoming the beautiful Miss Vernon. The image of Mary, in the far-away north, is very faint.

HOME AGAIN

More than twenty years have passed. The Cavendish Square house is let to Sir Martin Archer Shee: Romney has given up portrait painting, and in the Hampstead studio purposes to devote himself to heroic art and win immortality with his Miltonic subjects. But his health grows worse. The game is up. Oppressed, conscious of numbness in his hand and a swimming in his head, chagrined at the muddled failure of his building experiments at Holly Bush Hill, Hampstead—that "whimsical structure covering half the garden,"—where some of his pictures were destroyed by weather and others stolen, he longs only for peace and escape from himself. Yet how triumphant has been the course of those twenty years in Cavendish Square. Never throwing off the mask of the recluse, he has made friends after his own kind; he has moved in the Eartham set which revolved round the orb of the preposterous Hayley. There he met Cowper, and that "elegant female," Miss Seward, the "Swan of Lichfield," who would address him as "beloved and honoured Titiano," or as Raphael, while he would greet her as Sappho; Flaxman, too, he has known, who bought for him in Italy ten large cases of casts—the Laøcoon, the Apollo Belvedere, and so on. These the painter would exhibit to his select friends and pupils in his studio at night, a powerful lamp shining down upon the Laöcoon. Then was Romney happy. Away from the distraction of the "new face lit with the shock of eager eyes," he could bemuse himself with the contortions of the Laöcoon, and believe that he was surrounded by the creations of "great art."

But the game is now up. Sorely hurt in the battle, seeing nothing clearly, little dreaming how famous his portraits—"that cursed drudgery"—would make him in the twentieth century, he leaves London and makes his way back to Mary. She nurses him, and buries him after two years of "complete imbecility."

The sun is shining cheerfully in Cavendish Square, and Romney's troubles have been long quieted, forgotten in the pleasure his work gives us. No! I do not feel any sadness in recalling his life. Death pays all debts.

No. 32 looks very spick and span in the bright sunshine, and as I gaze at it I perceive above the tall ground-floor windows two heads of cherubs in stone, just like Sir Joshua's Heads of Angels in the National Gallery. Is it intentional, I wonder? Did the architect of this new house wish subtly to suggest that he, like Lord Thurlow, belonged to the Sir Joshua faction?

Maybe. I don't know, but I shall never pass the house without thinking so. Poor Romney! He hated irony and wit—and irony in stone is more enduring than irony in words or paint.

PLATE III.—MRS. MARK CURRIE
(From the picture in the National Gallery)

A typical and charming Romney. Miss Elizabeth Close married Mr. Mark Currie on January 18, 1789, and sat to Romney for the first time on the 7th of May in the same year. The painter received sixty guineas for this portrait.

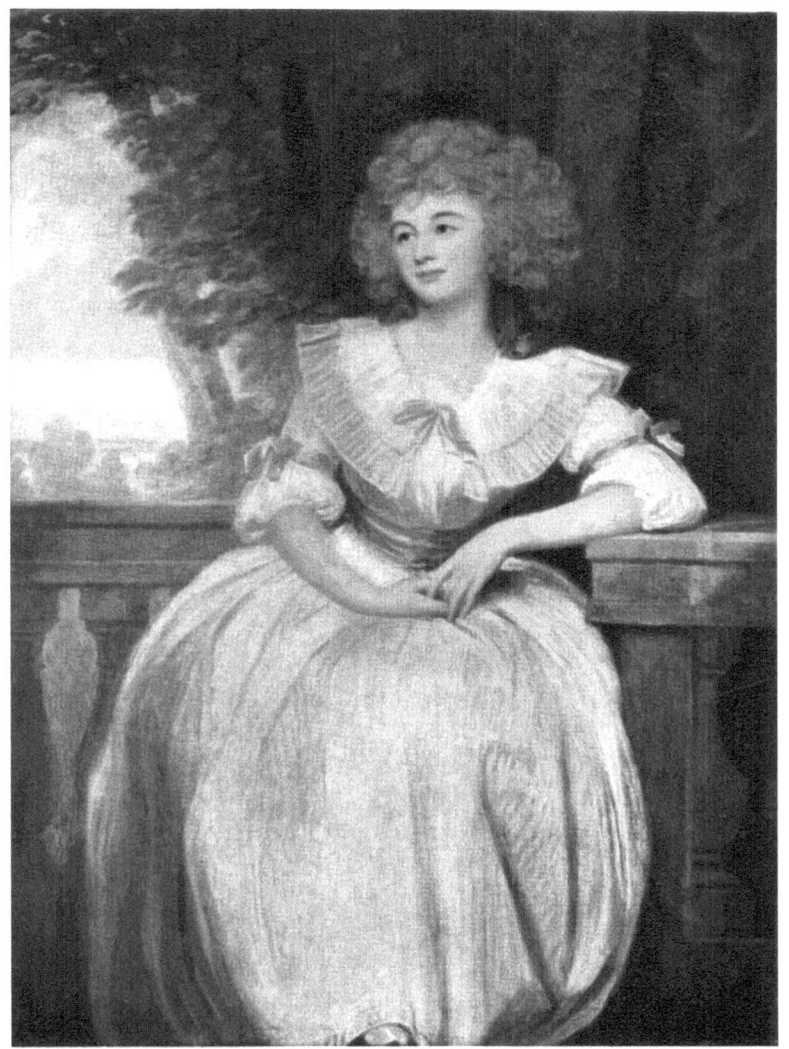

II

Romney, Reynolds, and Others

THE rivalry between Reynolds and Romney, that echoes faintly from eighteenth-century memoirs, is focussed by Thurlow's remark made in 1781: "The town is divided between Reynolds and Romney; I belong to the Romney faction." Romney returned the compliment by proclaiming that his full-length of Thurlow was his best production in portraiture—a judgment with which everybody disagrees.

Romney was an ill judge of his own work. Like most creative artists, he honoured the things that he did with difficulty, and cheapened those that were the true expression of his temperament. "This cursed portrait painting," he wrote to Hayley, at the age of fifty-two, "how I am shackled with it. I am determined to live frugally, that I may enable myself to cut it short as soon as I am tolerably independent, and then give myself up to those delightful regions of the imagination." In another letter he refers to portrait painting as "the trifling part of my profession." But that was when he was "shattered and feeble," and tired of the interminable sitters.

It is by his portraits that Romney lives, not by the heroic designs that were so near to his heart. We esteem him for his lovely faces set in a simple decorative design; his ambition was to excel as a painter of "sublime" and historical subjects—scenes from Shakespeare and Milton, and poetical themes for which his egregious friend Hayley ransacked the Eartham Library. Romney was sensitive, eternally in love with the fleet-

ing loveliness of women and children, the artist born in him again each time he saw a new face, but constantly diverted by his ambition, and by the bombastic sentimentalists moving in the Hayley mutual admiration circle at Eartham, where, for twenty years, he spent his summer vacation.

It would have been to Romney's advantage had he seen more of Lord Thurlow and less of Hayley. "Before you paint Shakespeare," cried the tonic Thurlow, "for God's sake read him!" On another occasion when the Chancellor was asked to subscribe to the Shakespeare that Romney and others were illustrating, he said: "What! is Romney at work for it? He cannot paint in that style; it is out of his way. By God, he'll make a balderdash business of it!" I suspect that it was not altogether artistic convictions that made the Chancellor ally himself to the Romney faction. There was more of the man in Sir Joshua than in Romney; and when Thurlow suggested to Reynolds that Orpheus and Eurydice would be an excellent subject for a series of pictures, Sir Joshua snubbed him. The pliable Romney, when Thurlow broached the idea to him, was delighted. He listened so sympathetically (we can imagine the appreciation in his large liquid eyes) to the Chancellor's translation of the episode from Virgil, that the great man was delighted with his *protégé*, asked him to paint the portraits of his daughters, and bought one of the four pictures which Romney had painted in illustration of Hayley's poem, "The Triumphs of Temper."

The composure of the benign Sir Joshua must have been ruffled by Thurlow's championship of his rival; but Romney, who was a modest man, may be said in his quiet way to have belonged to the Reynolds faction. He is recorded to have said that no man in Europe could have painted such a picture as

Reynolds's "Hercules strangling the Serpents"; and when a pupil told him that his picture of Mrs. Siddons was considered superior to Reynolds's portrait, he answered, "The people know nothing of the matter, for it is not."

Romney never sent a picture to the Royal Academy, and consequently his name never came up for election. He seems to have thought that to a man of his excitable temperament it would be better to pursue his art cloistrally and to avoid competition. Hayley encouraged him in this. Romney was his private preserve, and the painter submitted to the ring-fence that his cunning friend built about him.

In 1781 the town may have been divided between Reynolds and Romney, but posterity has a clear idea of the rank of the masters of eighteenth-century portraiture. Ahead of all stand Reynolds and Gainsborough, followed at no great distance by the virile Raeburn; Romney takes rank above Hoppner, and below them is Lawrence of the decadence and his followers in the curtain and column school.

Looking at a fine Romney, such as "Mrs. Lee Acton," or "Mrs. Mark Currie," or "Lady Hamilton," with her left hand tucked beneath her chin, or the earlier painted Ramus girls, one feels that exquisiteness and simplicity of design can go no further; but pass from "Mrs. Mark Currie" to Raeburn's "Portrait of a Lady," hanging on the staircase of the National Gallery, from "Mrs. Lee Acton" to, say, Reynolds' "Nelly O'Brien" at Hertford House, or from Romney's "Mrs. Robinson" to Gainsborough's "Mrs. Robinson," and the superiority of Reynolds, Gainsborough, and Raeburn sounds out like a thunder-clap. Romney at his best is one of the glories of English portraiture, but in many of his multifarious portraits he is not at his best. Few painters are able to stand the test

of a collected exhibition of their works, and it is no wonder that Romney did not emerge artistically scatheless from the Grafton Gallery ordeal of his collected works in 1900. The first impression was delightful. "Charming!" one murmured, but in the end monotony ruled, and, satisfactory as his clear colour often is, the Romney brick-dust red is not eternally agreeable. Yet through him Lady Hamilton and other delightful creatures have achieved immortality. We may criticise, belittle, and place him; but a fine Romney produces the elation of sudden sunshine, or the first sight in spring-time of a bank of primroses.

He had no recreations except his violin: his life was entirely devoted to his art. At Eartham, during his summer holiday, he worked incessantly. There, in "a riding-house of wood" converted into a studio, which "afforded him a walk of a hundred feet under cover," he "meditated" on the various pictures from Shakespeare that he meant to produce. In London, at the height of his prosperity, he worked till bedtime, occasionally when the days grew longer drinking tea at Kilburn Wells, or dining at the Long Room, Hampstead. Married early, he left his wife, as all the world knows, to seek fame in London at the age of twenty-eight, found it, enjoyed it, lost his health, became hypochondriac, and returned to his wife, at the age of sixty-five, a broken and shattered man. His biographers have censured or excused his marital conduct. Mary seems to have made no complaint. She knew George and understood him, knew that he had ceased to care for her, and that his art held, and would always hold, chief place in his affections. I am not tempted to play the part of moralist. Romney's niche in the Temple of Fame is as painter, not as husband. Tennyson treated the domestic side in his poem "Romney's Remorse."

The painter, according to the bard—

". . . made
The wife of wives a widow bride, and lost
Salvation for a sketch."

Edward Fitzgerald, a bachelor, observes in one of his letters: "When old, nearly mad, and quite desolate, he went back to her, and she received him and nursed him till he died. This quiet act of hers is worth all Romney's pictures; even as a matter of Art, I am sure."

Romney supported his wife, no great tax on a man who made nearly £4000 in one year, and he paid her two or three visits in the course of his triumphant career. The ugly part of the story is that he posed in London as a bachelor.

Shy, something of a recluse, impressionable, with delicate perceptions that made him a favourite among women, he was a man of good physical strength and robust appearance. According to Cumberland, he talked well. His harangues on art were "uttered in a hurried accent, an elevated tone, and very commonly accompanied by tears, to which he was by constitution prone." We are also informed that a noble sentiment never failed to make his eyes to overflow and his voice to tremble.

The early biographies of Romney were written to counteract one another. Hayley's foolish volume of 1809 was composed to correct the "coarse representation" of Cumberland, which was published in the *European Magazine.* Cumberland was a sensible man, and he wrote well. The useful but too appreciative volume by his son, John Romney, was a counterblast to Hayley. Later lives have been George Paston's admirable study, and the indispensable *Catalogue Raisonné* by

PLATE IV.—THE PARSON'S DAUGHTER: A PORTRAIT

(From the picture in the National Gallery)

This dainty portrait was called "The Parson's Daughter" by a former owner. Romney must have enjoyed the brief task of painting her. She gave him no trouble, you may be sure. Easily as a thrush sings he suggested the powdered hair framing the coquettish face masked in demureness, the long neck springing from the slight frame, and the note of green in the auburn curls.

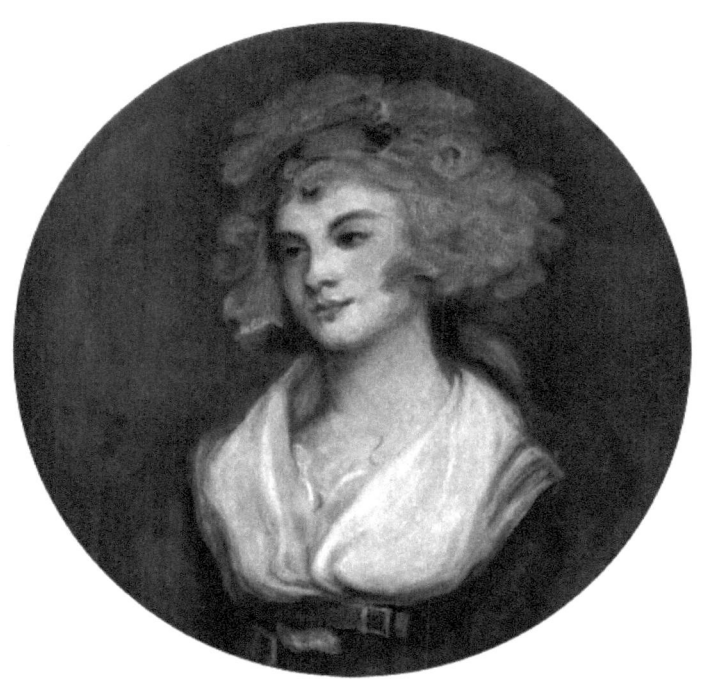

Mr. W. Roberts, with a biographical and critical essay by Mr. Humphry Ward, which also includes the text of Romney's Diaries from 1776 to 1795, acquired at Miss Romney's sale in 1894.

Romney lived in an age when men and women of sensibility wrote poems of praise to one another. Cowper's is perhaps the best known.

> "But this I mark, that symptoms none of woe
> In thy incomparable work appear."

It is poor stuff; but better than the effusions of Hayley, Miss Seward, and John Halliday.

III

His Vicissitudes of Fame

TO-DAY—one hundred and five years after his death—no millionaire's gallery is complete without a Romney, and the desire to possess a fine example grows fiercer yearly.

Doubtless, the purchasers at public auction in 1896 of the "Ladies Caroline and Elizabeth Spencer," in white and red dresses, for £10,500, and, in 1902, of Miss Sarah Rodbard fondling a Skye terrier curled up upon a stone pedestal, for the same price, were well content with their bargains. Romney received £84 apiece for these pictures. His "Lady Hamilton as Nature," which was bought by Mr. Fawkes of Farnley, Turner's friend, for 50 guineas in 1816 was resold after the Grafton Exhibition for, it is said, 20,000 guineas. The picture is now in Paris.

The witchery of his portraits of dainty dolls, the sweet composure of his young matrons, the charm of his children, the delicacy of his presentments of men, such as the "Wesley" and the "Warren Hastings," captivate the unlearned as well as connoisseurs. The appeal of his gift for expressing momentary loveliness is instantaneous. He was a poet in paint to a far greater degree than the so-called poets of the Eartham set were in words. No problem is offered; the freshness of the flower-like faces is stated simply and without hint of cleverness. The reticent colour lingers on sash or ribbon, and beneath the powdered fair hair the rose and cream tints of these pretty mondaines bloom like the petals of carnations

PLATE V.—LADY WITH A CHILD
(From the picture in the National Gallery)

The dark blue eyes of the child gaze out upon the world in reposeful wonder. The pose is delightfully natural. Romney's genius for design never failed him when his subject was a girl, a mother and child, or a group of children at play.

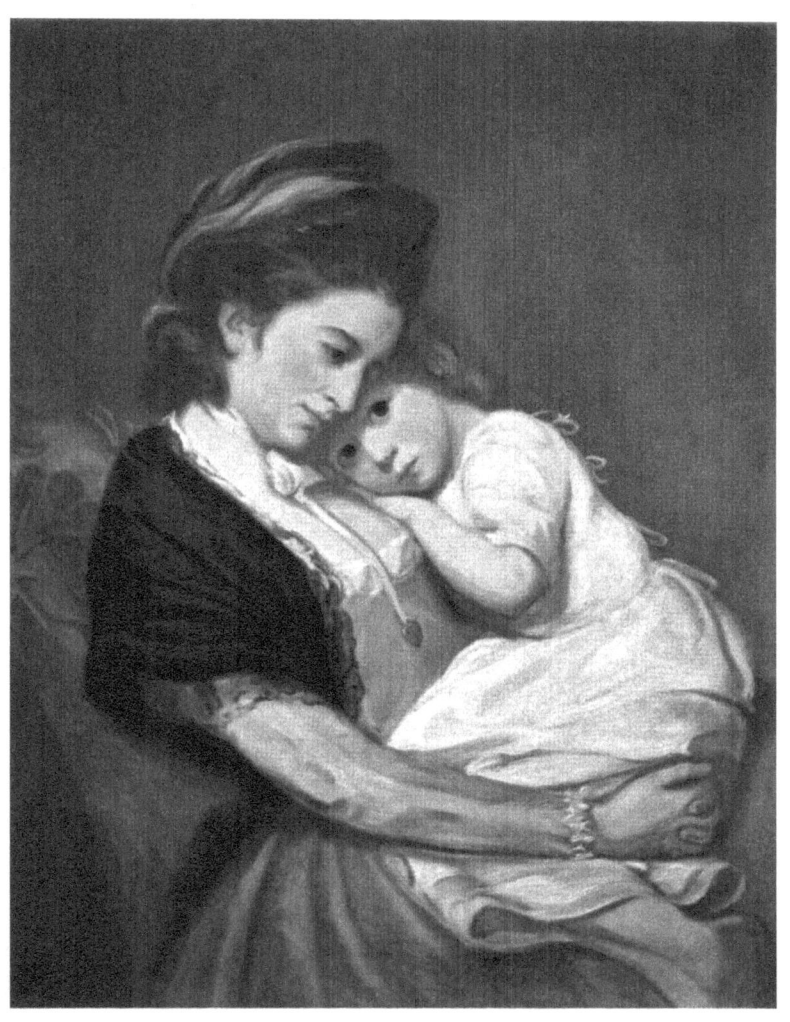

against the light. So virginal are the typical Romney ladies, that it is almost a shock to read that some of the portraits were never paid for, because the bright creatures had been passed on from the protector who gave the commission for the portrait. John Romney found a neat phrase when he said that his father "could impart to his female figures that indescribable something—that *je ne sais quoi*—which captivates the spectator without his being able to account for it."

Strange it is that until the middle of the nineteenth century, when the Romney revival began, fostered by the "Old Masters' Exhibitions" and auction sales, his fame had suffered an almost total eclipse. His portraits were hidden in private collections, the National Gallery set had not been acquired, and nobody cared about his heroic and historical cartoons and studies, at Cambridge and elsewhere.

The eclipse of the fame of Romney is no doubt partly due to the fact that he never exhibited at the Royal Academy, which in those days meant that "outsiders," so far as the public was concerned, were truly in outer darkness. When Romney retired from contact with the fashionable world, with which he never associated himself except as a painter; when he forsook his disastrous building experiments at Hampstead, for the living death (of his later years) at Kendal, he passed out of public life. His portraits ceased to be a topic. There were no weekly art columns in newspapers to fan the embers of his fame; the National Gallery was not founded, and the age of illustrated essays on private collections had not dawned.

The pages of the Diaries record, as I have already said, about nine thousand sittings in less than twenty years—a colossal labour; but some of the portraits were never finished, others have been lost or stolen. He kept no Diary until he had settled

in Cavendish Square in 1775, after his journey to Italy. Before that period Romney had painted hundreds of pictures of which but scanty records remain. A few examples may still be found in the houses of the descendants of the original owners around Kendal.

Forty-five portraits of Lady Hamilton are recorded in Messrs. Ward and Roberts' *Catalogue Raisonné*, sixteen illustrations of Shakespeare, two of Milton, and over fifty miscellaneous and Fancy subjects. In the Fitzwilliam Museum at Cambridge are a number of Pictorial Designs and studies presented by the Rev. George Romney in 1817, and at the Liverpool Royal Institution are eighteen cartoons, presented in 1823.

It would be unjust to call these historical and heroic subjects a monument of misdirected effort; but if Romney's claim to fame rested upon them, he would be of less account even than West and Fuseli.

His ardour was indefatigable, but it often spent itself when the novelty of beginning a sketch or portrait had worn off. In reading, too, his quick imagination soon flagged. At the end of one act, even of one scene, of Shakespeare's, he was ready to begin his picture. "The more he painted," says Hayley, "the greater was his flow of spirits." A friend surprised him one night working at an "Accusation of Susannah by the two Elders" by lamplight. It was never finished. Late in life he conceived a Gargantuan scheme of founding a Milton Gallery which should rival Boydell's Shakespeare Gallery.

The most attractive of his fanciful subjects is "Shakespeare nursed by Tragedy and Comedy," perhaps because Lady Hamilton was the model for Comedy (not in person; she was in Naples at the time), and Romney's brush was always inspired when he painted her adorable face. Shakespeare—a robust,

nude babe—sits on a cradle in the landscape holding a flageolet, to the accompaniment of endearments from the pretty Tragedy and Comedy ladies. The least attractive, indeed the silliest, is the "Shipwreck," an early work engraved in Hayley's *Life*. A huddle of exaggeration and emphasis, it has all the vices of the melodramatic heroic pictures of the period.

Romney had some talent as a musician, and as a boy he debated whether he should be a musician or a painter. Cumberland records that once he heard the painter perform on his own home-made violin in a room hung with his own pictures—"a singular coincidence of arts in the person of one man."

Reviewing his life, I seem to see him drawing, like Paganini on a memorable occasion, exquisite strains from one string only—Romney of the one string—a fantasia on the beauty of fair and fragile women, pretty and graceful children, and delicate-visaged men, the sweetest sounds coming when he extemporised in praise of Emma, the "divine lady" who came into his life when he was forty-eight, and who renewed his youth.

IV
His Portraits in Public Galleries

THE National Gallery possesses in "Mrs. Mark Currie," purchased in 1897, a typical and charming Romney. The pose, the reticent colour, the simplicity of the design, the background landscape, all please the eye. There is no sign of the labour that he bestowed upon his Shakespearean picture of "The Tempest," that formidable enterprise, containing eighteen figures, which was pruned and extended to meet suggestions of his friends.

Mrs. Mark Currie sits demurely self-conscious, as his quick eyes saw her in the first impressionistic glance, artfully clad in a simple muslin dress, relieved by the pale crimson sash and the ribbons of the same colour that nestle in fichu and sleeves. The fair hair is powdered; the large eyes gaze from the soft oval face conscious of, and content with, its comeliness; the landscape is sufficiently reminiscent of nature to harmonise with the pretty artificiality of the contented little lady who left Duke Street, Bloomsbury, to sit in the studio of "the man in Cavendish Square" on May 7, 14, 25, July 1, 9, 22, of the year 1789. "Paid for," continues the extract from the Diaries in the *Catalogue Raisonné* "in full by Mr. Currie, December 1790, £63; sent home June 20, 1791."

It was through Romney's influence that a delightful change towards simplicity and slight and delicate colours was made in the feminine fashions of his day, for he persuaded some of his sitters to discard the ugly, long-waisted bodices in favour of the simple white gown and fichu that Mrs. Mark Currie wears.

Emma Hart he clothed according to his fancy. I shall devote a separate chapter to her, but we must glance at his charming portrait of the "divine lady" as a Bacchante that hangs near Mrs. Mark Currie.

It is a study, possibly for the larger picture; the light brown curls, partly confined by the yellowy swathe, escape in disorder over the smooth brow. The mocking eyes glance sideways, the chin rests upon the shoulder, which, for Romney, is daringly bare; an impression, a momentary attitude, roughed in with his favourite red, done in a morning—a mood of Emma's, who could take any pose at an instant's notice, always charming and always inspiring to the painter. Near by is another sketch of Emma, rather hot in colour. The rich brown hair, in tempestuous disorder, flows over a pillow, the mouth is open, the eyes are as near to tragedy as the volatile Emma could go. So she must have looked during that weary time in Naples, when Charles Greville, of the level head and the tepid heart, whom she truly loved, would not write, and refused to reopen his arms to his young and deserted flame. "O, Grevell, what shall I dow? what shall I dow?" she wrote. At a Spelling Bee, Emma and Romney would have competed for the lowest place.

The oval known as "The Parson's Daughter," a title given by a former owner to the dainty girl with the large eyes and the tilted nose, is also essential Romney. She gave him no trouble, you may be sure. Easily as a thrush sings he painted the powdered hair framing the pretty face, the long neck springing from the slight body and the note of green in the auburn curls.

Country cousins who visit the National Gallery always pause before his "Lady with a Child," attracted by the naturalness of the little one, whose dark blue eyes gaze with reposeful won-

der at the spectator, and by the clarity of the paint. Romney's genius for design rarely failed him when his subject was a girl, a mother and child, or children at play, such as the buoyant group of the little Gower family dancing in a ring. To realise how hard and tight his handling could be when not inspired by his subject, look at the early "Portraits of Mr. and Mrs. William Lindow," in the adjoining room, painted in Lancaster in 1770 before his visit to Italy. If this highly-glazed group was not duly catalogued under his name, one could hardly believe it to be a Romney.

The "Mr. Morland of Capplethwaite," in hunting costume with a dog, is another hard and uninteresting early Romney. His son, in the *Memoirs*, grows excited over the dog. "No representation," he wrote, "can approach nearer to the truth of nature than the portrait of this dog; the sleekness of the skin, and the characteristic sagacity of the animal are so well depicted as to give it the appearance of reality."

Neither is the remaining Romney in the National Gallery, "Portrait of Lady Craven," a first-rate example, although it has its own sedate and simple charm. This oval once hung in the breakfast-room at Strawberry Hill, and inspired Horace Walpole to compose the following lines:—

"Full many an artist has on canvas fix'd
All charms that Nature's pencil ever mix'd—
The witchery of Eyes, the Grace that tips
The inexpressible douceur of Lips.
Romney alone, in this fair image caught
Each Charm's expression and each Feature's thought;
And shows how in their sweet assemblage sit,
Taste, spirit, softness, sentiment and wit."

PLATE VI.—MRS. ROBINSON—"PERDITA"
(From the picture in the Wallace Collection)

Hanging on the same wall in the Wallace Collection as Reynolds's seaward-gazing "Mrs. Robinson" and Gainsborough's superb full length, Romney's portrait of the famous lady is put to a severe test. Nevertheless, this small picture of "Perdita," with a muff, dressed for walking, looks very charming.

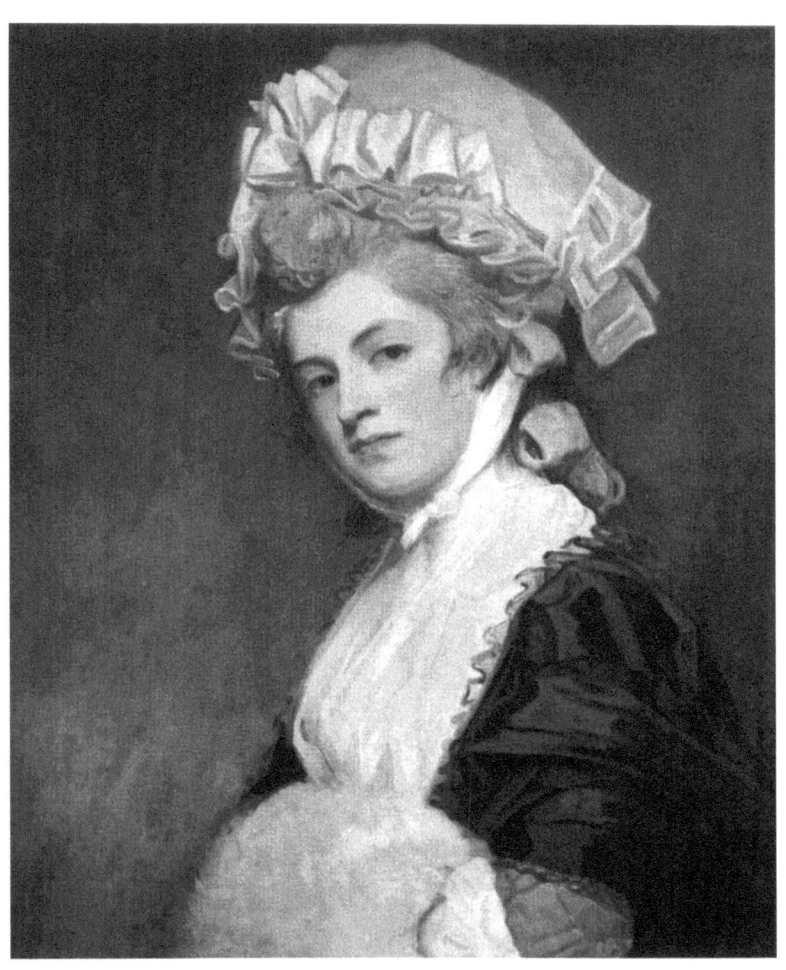

Romney does not shine in the Wallace Collection. His sole example, "Mrs. Robinson," is but a "twinkling star" (his own phrase to express the charms of the greatest beauties of the eighteenth century compared with Lady Hamilton) in the galaxy of masterpieces in the large gallery at Hertford House. Hanging on the same wall is Reynolds's version of seaward-gazing "Mrs. Robinson," and the superb full length by Gainsborough that dominates the Gallery, quite eclipsing our Romney's modest presentment of the famous lady, dressed for walking, with her hands in a muff. Her high powdered hair is crowned by a cap, the strings of which are tied beneath her plump chin. There is more character and resolution in the face than in the generality of Romney's portraits. Indeed, she is almost matronly, but the complexion has all his rose-leaf freshness; the touch of colour he permits in the sleeve is characteristic.

This room at Hertford House, with its three portraits of Mrs. Robinson, by Reynolds, Gainsborough, and Romney, is the place to brood over and speculate upon the dazzling career of this charming woman. A recital of the facts is enough; imagination can supply the rest. First a *protégé* of Hannah More; then the attraction of the town as "Perdita" at Drury Lane, she dazzled the Prince of Wales and became his mistress. In receipt of a pension of £500 a year at the age of twenty-five, she amused herself writing novels, poems, and plays, was a member of the Delia Cruscan School, and died, "poor and palsied," in 1800 at the age of forty-two.

Among the nine Romneys at the National Portrait Gallery is a winsome and smiling Emma. Her elbows are upon a table, and her firm chin rests upon her hands; but face and hands suffer from an excess of the Romney red. Here also is the crayon

sketch of Cowper which inspired the poet's sonnet to Romney, and of which Cowper wrote, "Romney has drawn me in crayons, and, in the opinion of all here, with his best hand and with the most exact resemblance possible"; his friend Richard Cumberland gazing upwards for inspiration; a "Flaxman modelling the Bust of Hayley," an example of "heroic portraiture"; and the Adam Walker family group—the last picture Romney painted, and interesting for its connection with William Blake. In a letter to Hayley, after Romney's death, Blake, who was collecting material for the *Life* by Hayley, wrote in 1804: "He (Adam Walker) showed me also the last performance of Romney. It is of Mr. Walker and his family, the draperies put in by somebody else. It is an excellent picture, but unfinished."

Unfinished also is the large autograph portrait of himself "as he appeared in the most active season of his existence," painted at Eartham in 1780. "He looks a man of genius" is the comment of visitors to the National Portrait Gallery. Certainly he looks an impressionable, sensitive, and easily moved man, with his large, somewhat mournful eyes and the high brow. Place beside Romney's portrait a photograph of Huxley, and you have two types, poles apart, remote as a Perugino from a Frans Hals.

A noble portrait is that of Warren Hastings at the India Office, everything subservient to the finely-cut head with its fringe of silvery hair, and the dark grey eyes looking shrewdly out at the world. Romney took his colour from his environment. With a lovely woman before him he painted loveliness; confronted by Warren Hastings he painted intellect and power; confronted by a Wesley, intellect and spirituality. But he failed when he tried to imagine something "noble and heroic," such as the melodramatic "Milton Dictating 'Paradise Lost' to his

Daughters," or a story picture such as the replica of "Serena reading 'Evelina' by Candlelight," at the South Kensington Museum. What inspiration could he derive from Hayley's "Triumph of Temper." The personality of Warren Hastings or Charles Wesley could stimulate his genius—not such verses as the following:—

> "Sweet Evelina's fascinating power
> Had first beguil'd of sleep her midnight hour;
> Possesst by Sympathy's enchanting sway
> She read, unconscious of the dawning day."

V

His Portraits in Private Collections

THE names of Reynolds, Gainsborough, Raeburn, Romney, and Hoppner are universally known, and many of their pictures, not always the best examples, are familiar; yet how few Britons have any idea of the chronological life-work of these masters. Their pictures in our public galleries are chance acquisitions, sometimes representative, often mere byways of their achievement.

Romney was an unequal painter. A classification of his achievement in order of merit would begin with the score or so of masterpieces, and dwindle downwards through his good, fair, poor, and bad pictures. There is no other word but bad for such productions as "The Shipwreck" and "The Infant Shakespeare surrounded by the Passions"; and if bad be an unfair description of "Newton Displaying the Prism," it is certainly a poor picture, although better than "Milton Dictating 'Paradise Lost.'" I have only seen a photograph of "Newton Displaying the Prism," but Redgrave, who examined the picture in the early sixties, describes it as poor in drawing, dirty and hot in colouring, and weak and common-place in treatment.

Romney stands or falls by his portraits and portrait groups, by the score or so of masterpieces that he painted better than he knew. These are the true "great art," the presentment through the eyes of temperament and training of the thing seen, that he was always striving to escape from in his pursuit

of a false "great art," which he struggled to approach through the portals of literature guided by other eyes and other brains.

The inequality of Romney was shown at the 1907 Old Masters' Exhibition at Burlington House. In the six contributions from his brush, or ascribed to him, there was one superb example, the second Mrs. Lee Acton; one good example, the first Mrs. Lee Acton, and one bad example, the hard and discordant sketch of Edward Wortley Montagu. The muddy portrait of a "Lady in a White Dress," and the dull and common painting of the Rev. Thomas Carwardine, although not as bad as the Edward Montagu, were indeed poor Romneys. One only had to turn from the "Lady in a White Dress" to the Raeburn, "Mrs. Anderson of Inchyra," to realise the difference between journeyman-work and inspiration, between a muddy amalgam of paint, and quality and vivacity.

But the second Mrs. Lee Acton! Ah! there was Romney at his loveliest, easy in mind, seeing the completed design from the inception, unworried by any literary groping after arrangement on the lines of "great art," instantly inspired by the beauty of this second wife of Nathaniel Lee Acton of Livermere Park and Bramford, Sussex, when she rustled into his vision one day in 1791. This Dryad, masquerading in the pretty clothes of a mortal, lurks in a glade; her dainty feet rest near a pool of blue water; her white dress, the simple gown that no doubt Romney persuaded her to wear, golden in the sun, which is setting behind the distant hills and flushing the trees to warmth. Her complexion has the peach-like porcelain quality in which Romney, at his best, rivalled Gainsborough; and as for her fair powdered hair, I think the secret of its touch-and-go, intimate rendering is now lost. There is hardly any colour in the picture, and yet it is all colour. Time, no doubt,

has co-ordinated the glow that enwraps and illuminates this sophisticated Dryad, whose folded hands and arch simper seem to announce that her momentary condescension has given the painter immortality.

Recalling the pleasure that a beautiful Romney such as this gives, and eager to pass on my delight to my friends, I imagine a room hung with reproductions of fine Romneys, where the twentieth century could burn a little incense to the eighteenth-century master. But there must be two rooms, for Lady Hamilton must have a compartment to herself, as in this little book.

The Romneys in the first room would include a reproduction of this "Mrs. Lee Acton" from the collection of Lord de Saumarez; "Mrs. Mark Currie," "The Parson's Daughter," and the "Lady with a Child" from the National Gallery, with "Mrs. Robinson" from the Wallace Collection. Beside them I would place those adorable girls, Miss Ramus and Miss Benedetta Ramus, who were also painted together by Gainsborough in the picture known as "The Sisters." That lovely work was, alas! burnt in the fire at Waddesdon. I remember a poem by Mr. Andrew Lang in Longmans' Magazine on one of these sisters. A verse ran—

> "Mysterious Benedetta! Who
> That Reynolds or that Romney drew
> Was ever half so fair as you
> Or is so well forgot?
> Those eyes of melancholy brown,
> Those woven locks, a shadowy crown,
> Must surely have bewitched the town;
> Yet you're remembered not."

PLATE VII.—MISS BENEDETTA RAMUS
(From the picture in the possession of the Hon. W. F. D. Smith)

The younger of the beautiful Ramus girls, who afterwards became Lady Day. Miss Benedetta of the lovely eyes, that languish and sparkle as if pleading against oblivion, rests her hands upon a book in reverie. This beautiful girl and her sister were also painted by Gainsborough. That lovely work was most unfortunately destroyed by fire.

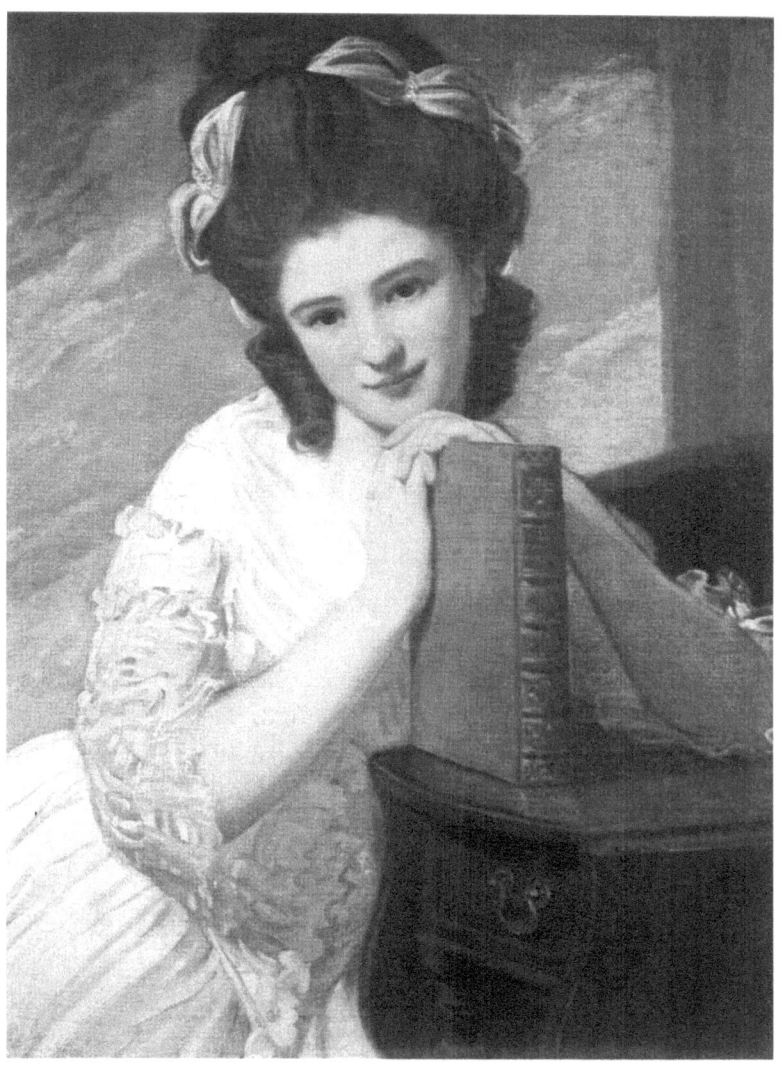

Forgotten? Remembered not? Living and very near seemed the sisters when I made an expedition to Henley-on-Thames, and was allowed to see Romney's portraits of Miss Ramus and Miss Benedetta in the hall of Greenlands, Mr. W. F. D. Smith's country house. These half-figure portraits have not the frolic daintiness of the "Mrs. Lee Acton," or the "Mrs. Mark Currie." They antedated those sparkling full-lengths by nearly fifteen years. Compared with them Miss Ramus and Miss Benedetta are almost prim. If Romney had wished to make them the centre of a sumptuous decorative scheme, the artist in him knew that such was not the way to treat those dark and dainty gentlewomen. Nowhere, I think, are there better examples of his simplicity of design and handling, his frank statement, without a fleck of personal cleverness or pride, than these sisters who smile on either side of the doorway that issues from the hall at Greenlands. Miss Benedetta of the lovely eyes, that languish and sparkle as if pleading against oblivion, lost in reverie, rests her hands upon a book. The binding of the volume is light brown, the table dark brown; there is a rosy flush in her cheeks and down the tips of her slim fingers; in the grey band, looped with pearls, that binds her hair there is a glint of green; otherwise, the portrait has little colour save in the break of blue sky that surges across the background. I suppose every one compares and makes a choice between the two sisters. The appeal of Benedetta is swiftest, yet when I look at Miss Ramus I know that I should not like to be obliged to choose. The bow of her red lips may be a thought too precise, but how vibrant she is in spite of her composure! how keen and quick the look of that high-bred face! No; I should not like to have to choose between the merry languishing Benedetta and the merry alert Miss Ramus, in her pink dress, with the

flaming green gauze veil, and the gleams of gold in hair and gown.

Another beautiful girl, "Miss Vernon as Hebe," now in Warwick House, would have an honoured place in my roomful of fine Romney productions. Well may this charming goddess claim to restore beauty and youth to those who have lost them. Abundant brown hair crowns the pure, untroubled brow; she glides forward, bearing the wine cup, and looking upwards as she advances. As in the Miss Ramus, candour and nobility have here taken the place of the Romney prettiness.

Perhaps it is the curling powdered hair, perhaps the pout of disdain on the lips or the flicker of contempt in the eyes, that gives to "Lady Altamount" (Lady Sligo) the air and very essence of an eighteenth-century aristocrat. This proud and fragile beauty found in Romney, son of a cabinet-maker, the man who could perfectly interpret her exquisiteness.

Does the large white hat, tied with blue ribbons beneath her chin, that "Miss Cumberland" wears, suit the lady? I think so, and so thought Romney, when this dark-eyed daughter of his friend Richard Cumberland decked herself one day in an old-fashioned hat to amuse her family. Romney happened to call, saw the charm of the decoration, and saw his picture.

When I come upon a portrait of a fragile blonde by Romney, I feel that he is at his best with fair women; when I see one of his bold beauties, such as "Lady Morshead," the tangle of her profuse brown hair contrasted with the simple folds of her muslin fichu, I feel that he is at his best with dark women. This "Lady Morshead," doing nothing, but looking charming; bright-eyed "Mrs. Raikes," playing on a spinet; the dark Cholmeley girls; bewitching Sarah with the ringlets; and the more dignified Catherine—they were painted on Romney's

best days.

A few of his "Mother and Child" groups must also have place on the walls of my imaginary room—the "Mrs. Russell," in a green dress at Swallowfield Park, holding the sash of her small child, who is standing upon a table, back to the spectator, regarding its chubby face in a circular mirror—a happy design this, most natural and winning; the "Mrs. Canning," seated beneath a tree and clasping her infant to her bosom, but quite conscious that her portrait is being painted; and the "Mrs. Carwardine," in a high white cap, who is consoling her baby and ignoring the painter—a charming and restful group.

Also the boy "Lord Henry Petty," at Landsdowne House, a quaint figure in his blue tail-coat and amber-coloured trousers, standing in an affected attitude, with his fingers marking the passage in a book, which he pretends to have been reading. The boy is posing. Romney did not always succeed in suggesting the simplicity of childhood. Even in the famous group of the "Children of the Earl of Gower," now in the possession of the Duke of Sutherland, delightful as it is, one is conscious that the actions of the children are not spontaneous. Clasping each other's hands, the lively creatures dance round in a ring, their sandalled feet tripping to a measure played by Lady Anne upon a tambourine held in the "grand manner" above her left shoulder. This group has been called Romney's masterpiece. The murmur of pleasure that rises to the lips at the first sight of the "Clavering Children" is checked by the feeling that the small boy must eternally and wearily hold his right arm outstretched on a level with his head. So Romney has fixed him, holding high aloft the leash that confines the two spaniels. Otherwise, the group is delightful. The little girl fondles a puppy, her brother's left arm clasps her waist, and the

PLATE VIII.—MISS RAMUS

(From the picture in the possession of the Hon. W. F. D. Smith)

Connoisseurs in beauty have long disputed as to which is the lovelier of the two Ramus girls painted by Romney. The bow of Miss Ramus' lips may be a thought too precise, but how vibrant she is in spite of her composure I how keen and quick the look of her high-bred face! It would be hard to make a choice between Miss Ramus and Miss Benedetto.

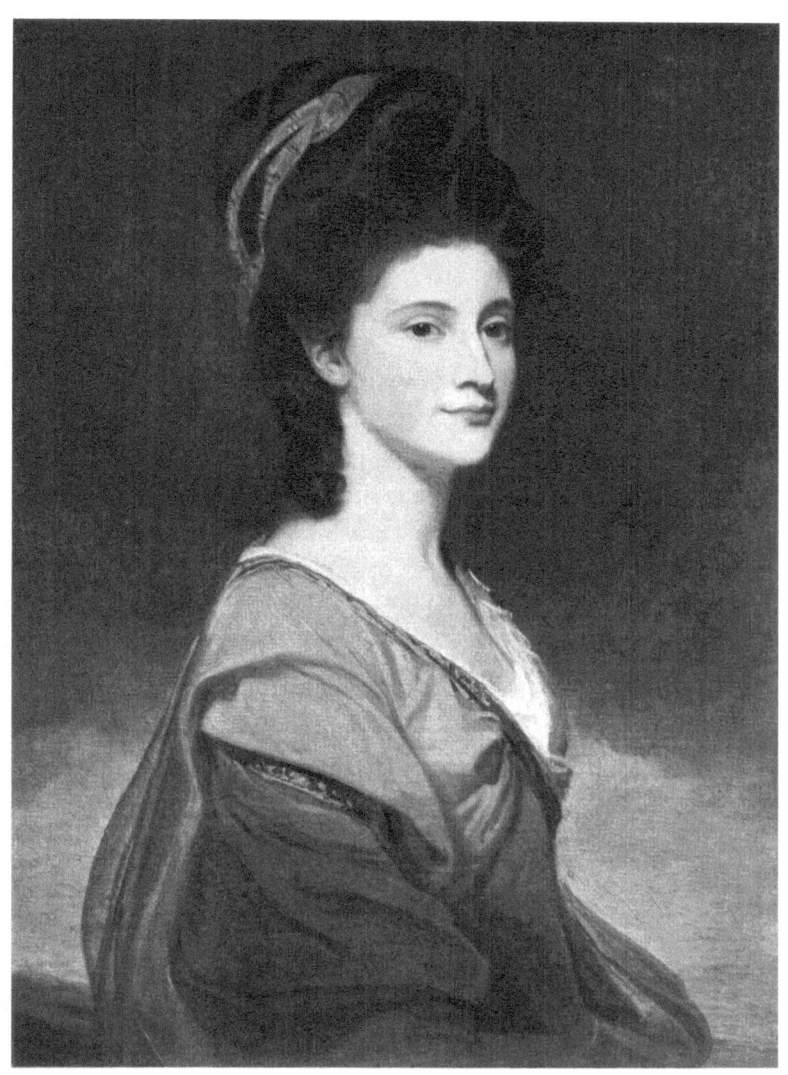

children, conscious that they are being watched, trip forward through the landscape. In another of the large groups, "The Countess of Warwick and her Children," there is something very taking in the small old-fashioned figure of the boy with the hoop, and in the intimate movement of the girl, who is whispering to her listening mother.

The group of "The Horsley Children," so simply painted and so sure, was designed on one of Romney's happy days. George and Charlotte stand on the steps of a garden terrace beneath a tree, in white dresses with blue sashes. In her right hand the girl holds poppies; in her left a corn-flower.

Two portraits of men I should include in my collection of significant Romneys—the "Warren Hastings," with its watchful dignity, and the inward smile that flickers on the calm, purposeful face of John Wesley. From the following extract, printed in *Wesley's Journal*, January 5, 1789, I judge that he, like Thurlow, belonged to the Romney faction: "Mr. Romney is a painter indeed. He struck off an exact likeness at once, and did more in an hour than Sir Joshua did in ten."

No one ever accused Romney of a lack of quickness. He could always begin; he could not always continue to the end.

VI

Emma, and The End

THE life of Romney, apart from his paintings, has interested the world in two particulars—his desertion of his wife and his passion for Emma Lyon. This extraordinary woman, the daughter of a blacksmith, began as a nursemaid: she suffered from libertines, loved Charles Greville and lived under his protection, married Sir William Hamilton, became world-famous as the beloved of Nelson, and died in Calais, an exile, where she was buried "at the expense of a charitable English lady."

Romney did not meet her until the year 1782, when he was forty-eight, although it has been suggested that the acquaintance began earlier. Certain it is that Greville brought the lovely girl to the studio in Cavendish Square in 1782, and that, until her departure for Naples in 1789, she was the joy, the light and the inspiration of Romney's life. Mr. Humphry Ward quotes in his Essay a letter Romney wrote to her at Naples, "astonishing in its orthography." A passage runs: "I have planned many other subjects for pictures, and flatter myself your goodness will indulge me with a few sittings when you return to England—I have now a good number of Ladys of (? fashion) setting to me since you left England—but all fall far short of the Sempstress. Indeed, it is the sun of my Hemispheer, and they are the twinkling stars. When I return to London I intend to finish the Cassandra and the picture of Sensibility." It was during her absence that the dejection

darkening his latter years began.

She returned in 1791, and joy revived when she tripped into his studio "attired in Turkish costume." Sunshine again flooded his clouding brain, and the man of fifty-seven writes thus to Hayley: "At present, and the greatest part of the summer, I shall be engaged in painting pictures from the divine lady. I cannot give her any other epithet, for I think her superior to all womankind." Shortly afterwards the painter was plunged into gloom by an apparent coolness on the part of the lady, but it passed. She again sits to him, and we read of Romney, the recluse, giving a party in Cavendish Square in her honour: "She is the talk of the whole town and really surpasses everything, both in singing and acting, that ever appeared." Then followed her marriage to Sir William Hamilton at Marylebone Church and return to Italy. Romney and Emma never met again. From Caserta she wrote him a long letter, which shows the innate goodness and sweetness of this beautiful butterfly, who was always pursued, and who was sometimes (not always unwillingly) caught. Here is a passage from that letter of simple self-revelation: "You have known me in poverty and prosperity, and I had no occasion to have lived for years in poverty and distress if I had not felt something of virtue in my mind. Oh, my dear Friend! for a time I own through distress virtue was vanquished. But my sense of virtue was not overcome."

Emma was not only a versatile actress; she was also an artist's model of genius, able to give charm and personality to any character she was asked to assume, and she was shrewd enough to see that there was no surer and more enjoyable avenue to a popular appreciation of her beauty than Romney's brush. Other men, including Sir Joshua, painted the auburn

hair, the perfect mouth, the flower-like complexion, the bewitching eyes, and the infinite phases of expression; but Romney limned her with the insight of a lover. For him there was no disillusion. He alone made her eternally beautiful. Did she love him? I think not. She liked him unfeignedly and was flattered by his admiration, but all her love, before the Nelson epoch, was given to Charles Greville. Her marriage to Sir William Hamilton was a bargain for social advancement. He, at the instigation of nephew Charles, appraised her beauty, and succumbed. Her early admirer, Sir Harry Featherstonehaugh, of Up Park, succumbed and rode away. Sir William Hamilton placed the nuptial ring upon the slender finger of his charmer. Emma sat to Romney once only after she had become Lady Hamilton, and after that sitting, on September 6, 1791, there is not a single entry in his Diary until the 12th of the following month. We may infer that the marriage and departure of the "sun of his Hemispheer" put him temporarily out of humour with painting. The most bewitching of his sitters could not fill her place. As well offer Charmian or Iras to Antony when Cleopatra was away.

In the *Catalogue Raisonné*, already mentioned, which contains all the extant information about Romney's pictures, the authors state that very many so-called "Lady Hamiltons" are neither by Romney nor of Lady Hamilton. Over eighty authentic examples remain detailed in their list. Romney painted many renderings of some of the fanciful characters for which Emma sat—as a Bacchante, for example, of which twelve versions are catalogued. The half-length in the National Portrait Gallery with the eloquent eyes, her rich hair confined in a long linen swathe tied turban-wise, I have already mentioned; also the mocking study in the National Gallery. The parent

of all the Bacchantes was the half-length painted about 1784 and sent to Sir William Hamilton at Naples, with Greville's comment: "The dog was ugly, and I made him paint it again." The best known is the full length in the possession of Mr. Tankerville Chamberlayne. Laughing, with head on one side, she glides beneath a tree, leading a goat that is fading into nothingness; but the dog, leaping and barking at the prospect of a scamper with his pretty mistress, is as lively as the lovely priestess of Bacchus.

Romney's earliest picture of Emma was the "Lady Hamilton as Nature," an attraction, in coloured reproductions of varying merit, of London print-shops. She is seated before a formal but charming landscape background holding a dog, almost too large for a pet, in her arms. The red dress is cut low, her bright hair is bound with a double green fillet. She is the personification of youth and gaiety, but let the eighteenth-century poet, who sang her praises as "Nature," speak—

> "Flush'd by the spirit of the genial year,
> Her lips blush deeper sweets—the breath of Youth;
> The shining moisture swells into her eyes
> In brighter glow; her wishing bosom heaves
> With palpitations wild."

So a picture may preserve minor verse.

It is amazing to recall that the full-length "Circe" realised but fourteen and a half guineas at the Romney sale in 1807. Twenty years later, in 1831, Croker's contemptuous query, "What is a Ramsey or a Romney worth now?" shows that the star of Romney was still obscured; but in 1890, at the sale of Long's effects, with the figures of the animals painted in by

that artistic surgeon, this same Circe realised 3850 guineas.

Bare-footed, with left hand upraised, she advances from the gloom of the rocks, lit on the left by a gleam of sky and sea. Her dress is pale red, the fillet in her hair and the veil that flows behind are pale blue; but it is the face at which we gaze, the pure, childlike, lovely face whose subtleties of simplicity were revealed to the eyes of her constant lover, so sure that in her he had found the realisation of the artist's dream.

It is difficult to say which of the Romney Lady Hamiltons is the most beautiful. Hard it is to choose between those I have mentioned and the lovely mystery of Sir Arthur Ellis's sketch for the "Cassandra"; or the dark hair hooded in white of "The Spinster"; or the startled eyes "Reading the Gazette"; or the half-length, belonging to Lord Rothschild, seated in pensive mood, with her left hand under her chin, the brow shadowed by the black hat, and the eyes pensive as a nun's.

A print-shop near Bond Street utilises a reproduction of this portrait as a hanging sign, as a tailor in Holborn uses the Moroni "Portrait of a Tailor." Men whose route from office to train lies through the neighbourhood have been known to go out of their way for the sake of a glance at Emma. She cheered Romney. She cheers still.

I might well end on this note. The rest, if not silence, is best forgotten. It has been referred to in the first chapter. Romney lived for eleven years after Emma's marriage and painted some good pictures, but he suffered increasingly from failing health and depression. In 1798 after the disastrous building experiment at Hampstead he sold the lease of 32 Cavendish Square to Martin Archer Shee and returned to his wife and child. He bought an estate at Whitestock, near Ulverstone, but did not live to build the house. His brain was clouded during the last

two years of his life, and his wife, nursing him, watched the "Worn-out Reason dying in her house." To faithful Mary he murmurs, in Tennyson's poem, these valedictory words—

> "Beat, little heart, on this fool brain of mine.
> I once had friends—and many—none like you.
> I love you more than when we married. Hope!
> O yes, I hope, or fancy that, perhaps,
> Human forgiveness touches heaven, and thence—
> For you forgive me, you are sure of that—
> Reflected, sends a light on the forgiver."

www.ingramcontent.com/pod-product-compliance
Lightning Source LLC
Chambersburg PA
CBHW030733180526
45157CB00008BA/3149